THE R O A D

photographs by

Brian Baker

curated by
Jennifer Sakai

BROOKLYN, NEW YORK
Publishing books since 1997

All rights reserved. No part of this book may be reproduced, stored in a retrieval system, or transmitted in any form, by any means, including mechanical, electronic, photocopying, recording, or otherwise, without the prior written consent of the publisher.

Published by Akashic Books
©2025 Brian Baker

Art Direction & Curation: Jennifer Sakai

ISBN: 978-1-63614-271-5
Library of Congress Control Number: 2025933490

First printing
Printed in China

EU Authorized Representative details:
Easy Access System Europe
Mustamäe tee 50, 10621 Tallinn, Estonia
gpsr.request@easproject.com

Akashic Books
Instagram, X, Facebook: AkashicBooks
info@akashicbooks.com
www.akashicbooks.com

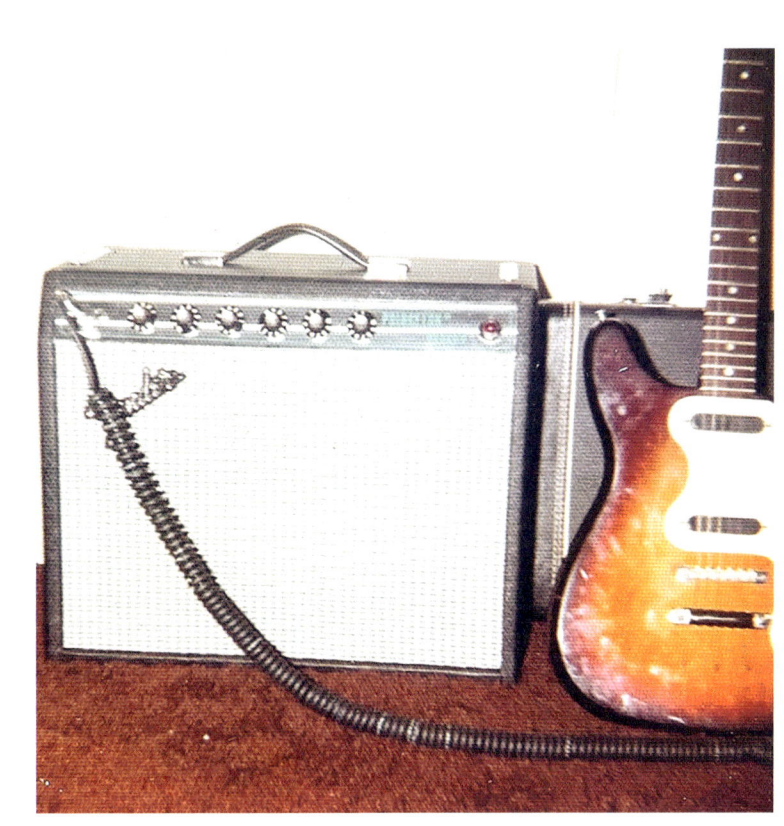

This goes out to everybody

The road takes time. It warps and distorts it, drags it and speeds it up. As a musician my job is to keep good time, no matter how squirrelly it gets.

The concerts themselves are natural for me at this point and seem to go by in a flash, and time spent on wheels or in the air is easily passed with naps or a good book. But navigating the long hours between sound check and showtime is the real challenge. I have found no better method than taking walks that are just a little bit too long.

On these walks my eye is drawn to hints of disorder; anomalies, like three things where there should be four, or finding a face in an inanimate setting. I look for an arresting combination of colors or a misspelled sign, or things that just seem either off message or overtly on. I hit a lot of parks, all the museums, and I do love an old church—they are cool in summer, rarely crowded in the afternoons, and who doesn't like a good story? If I am lucky they come with a graveyard at no extra charge.

All this walking and tenacious time management produced most of the photos in this book. All images were taken over a period dating precisely from the debut of the first iPhone to the present day.

March 2025

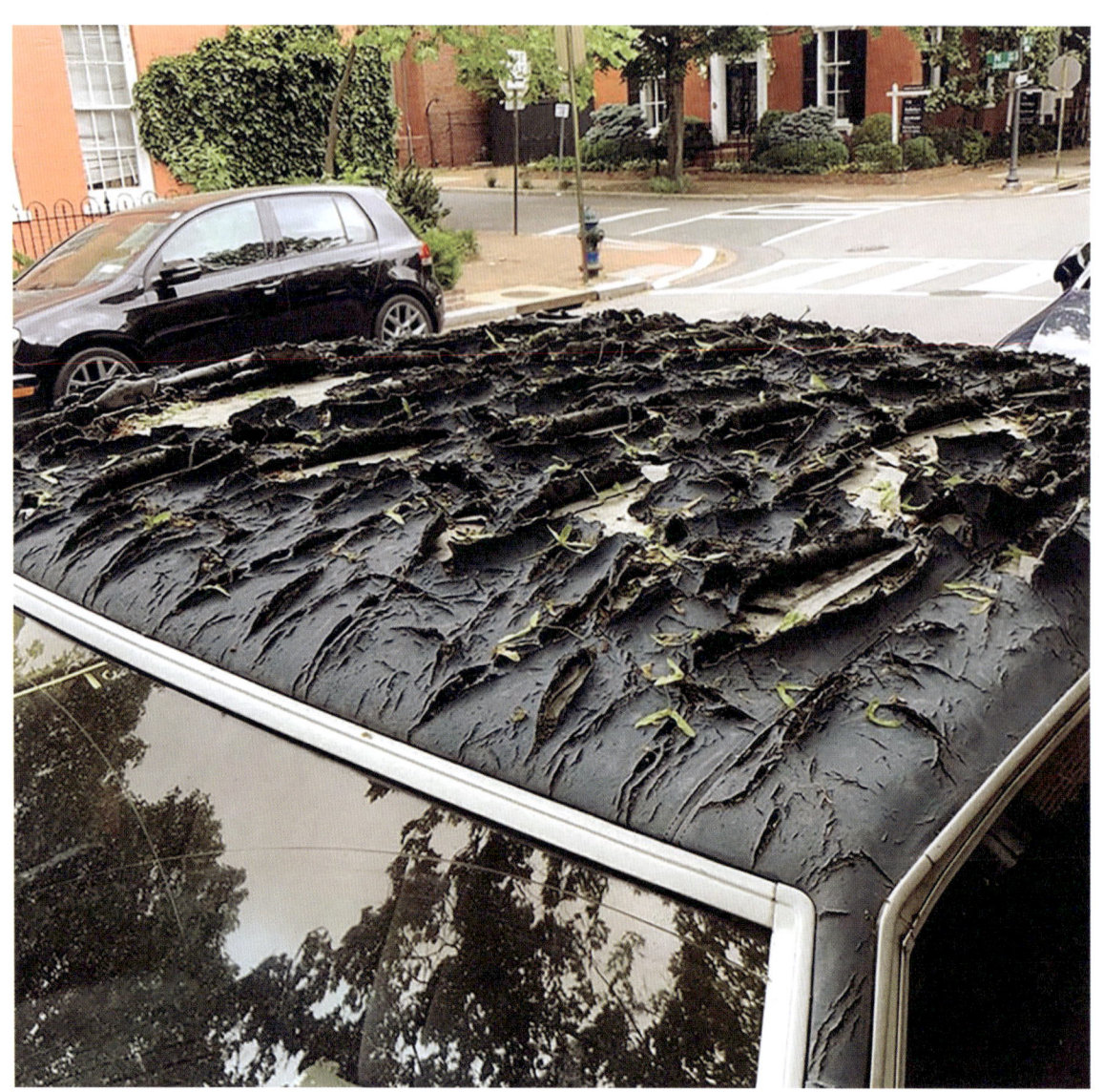

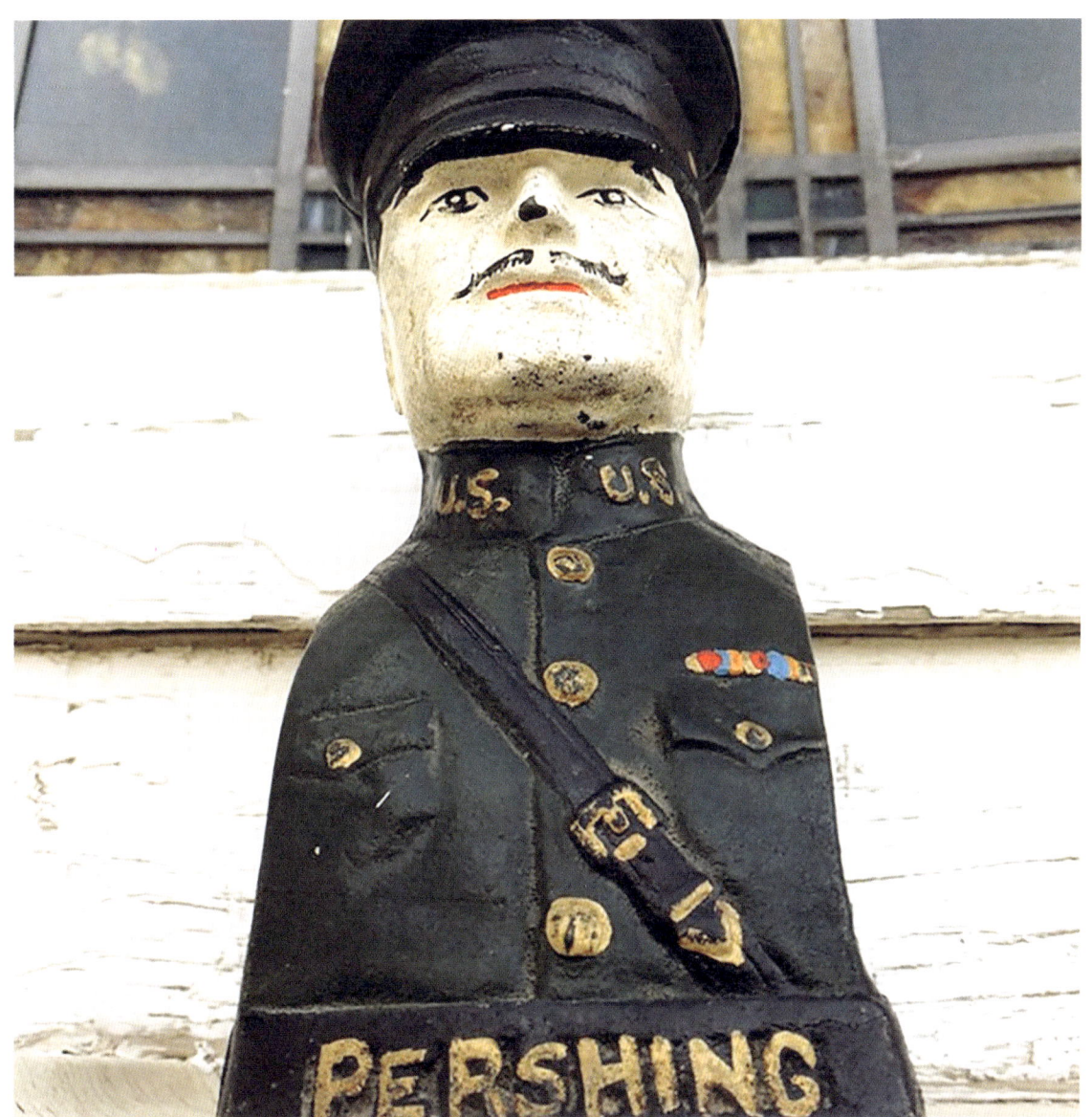

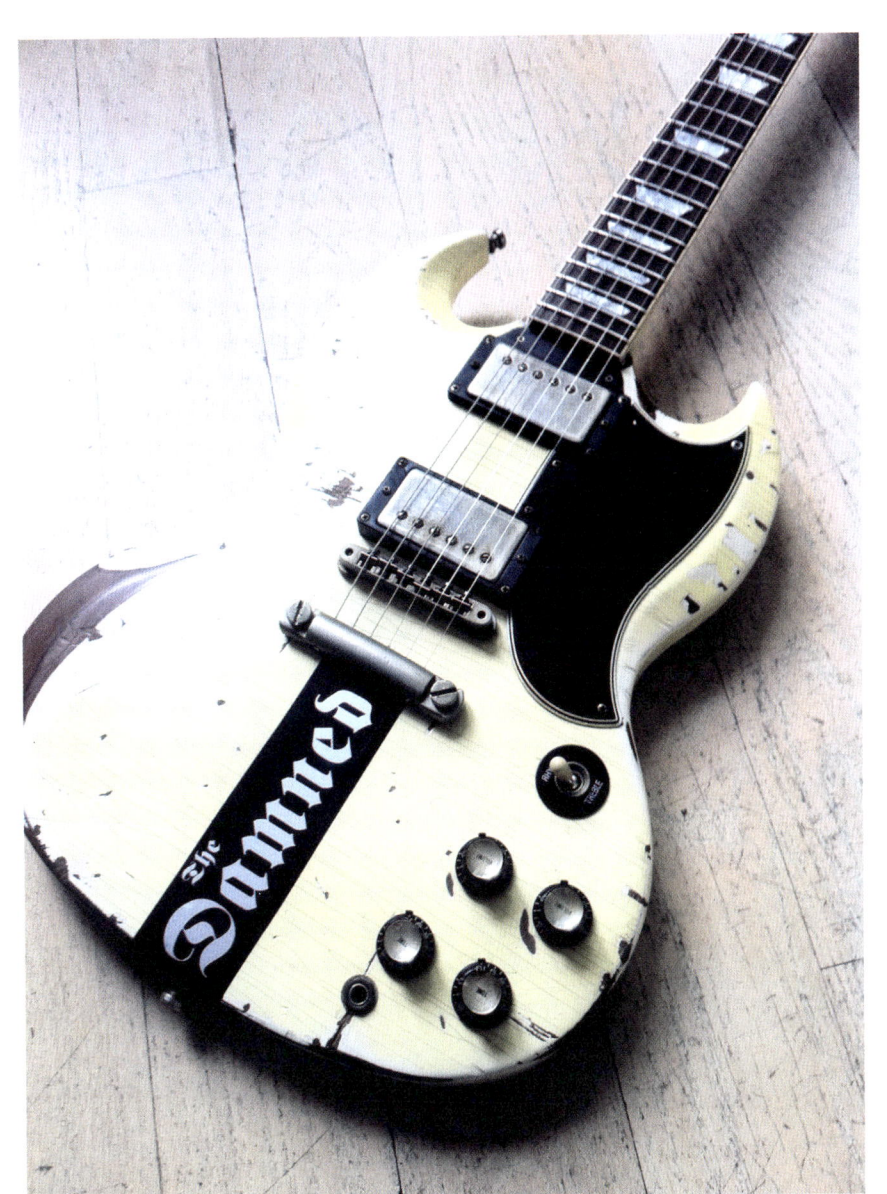

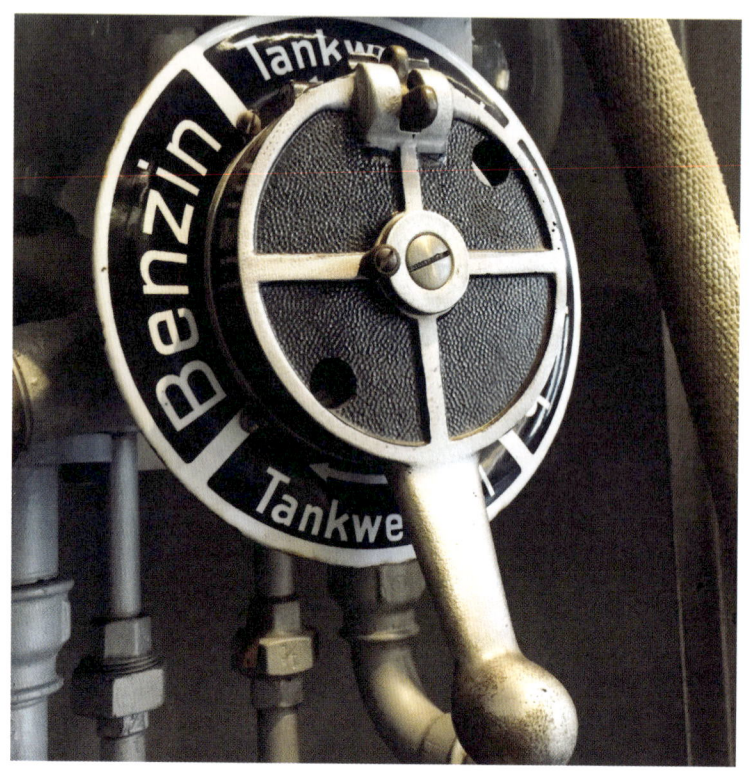

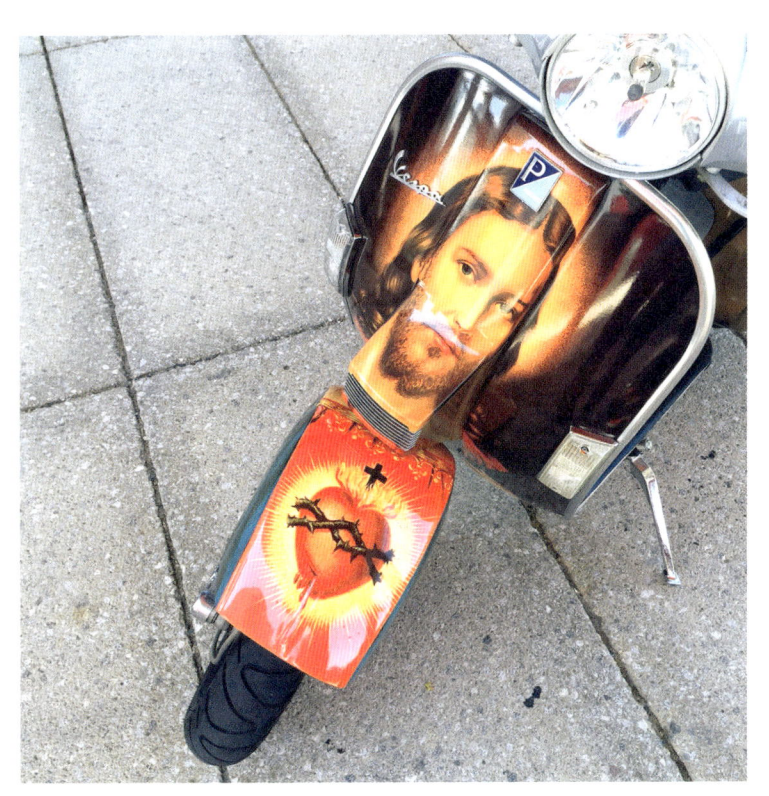
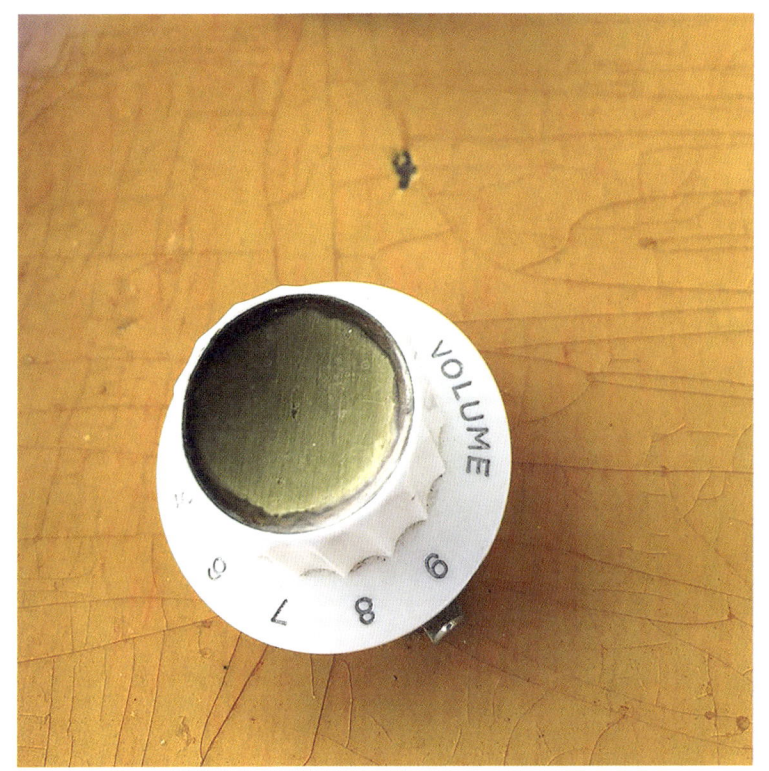

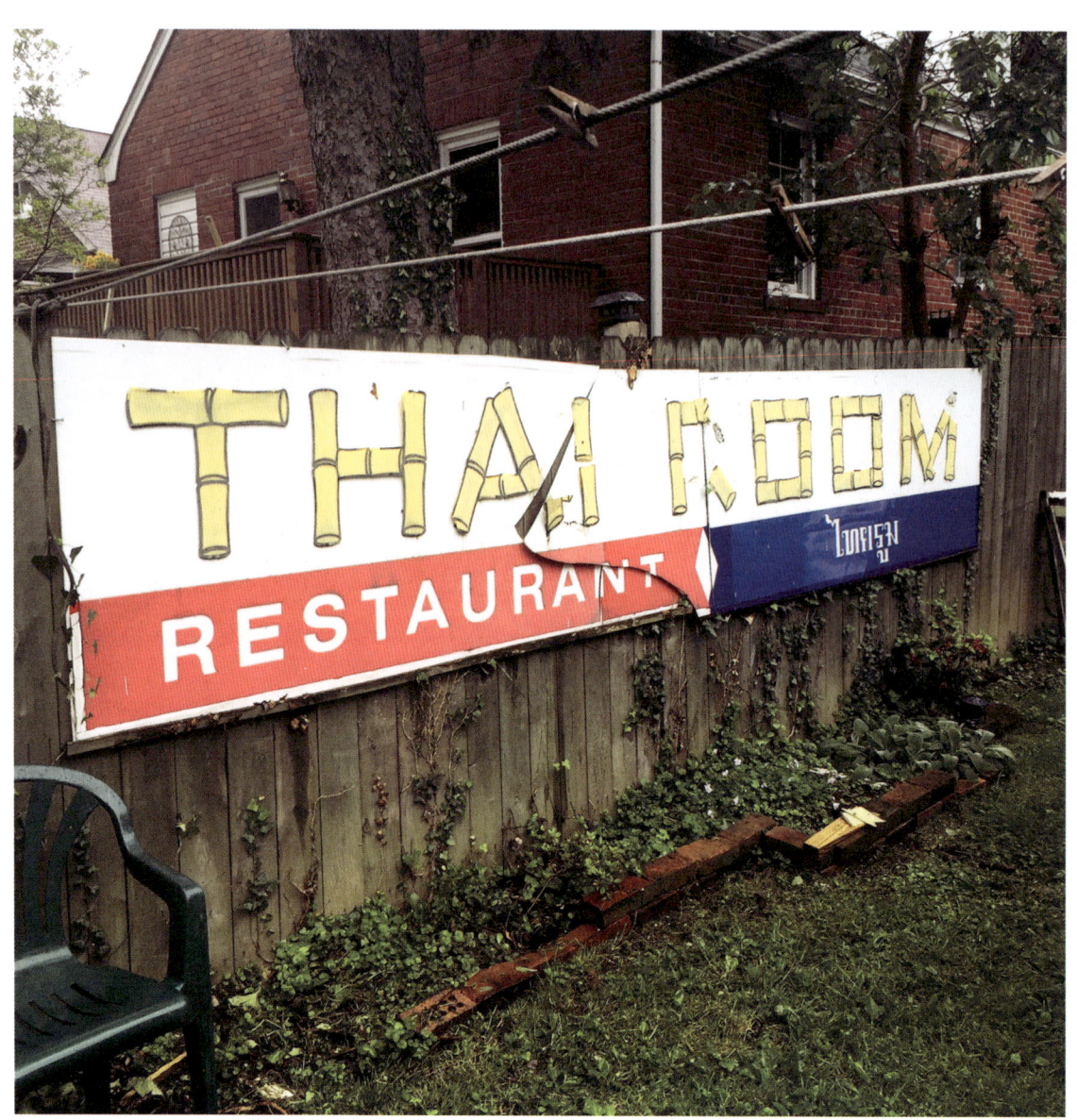

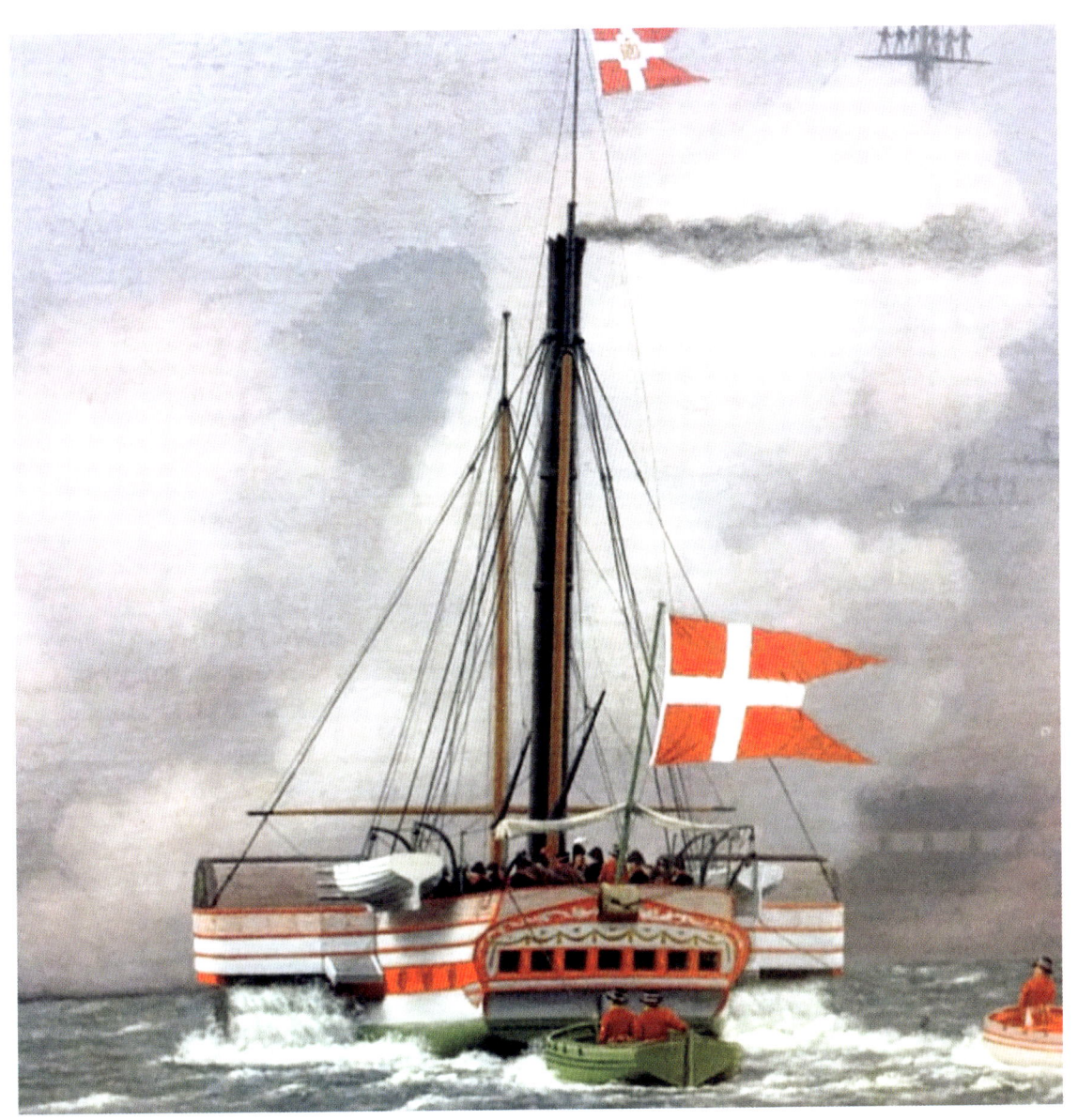

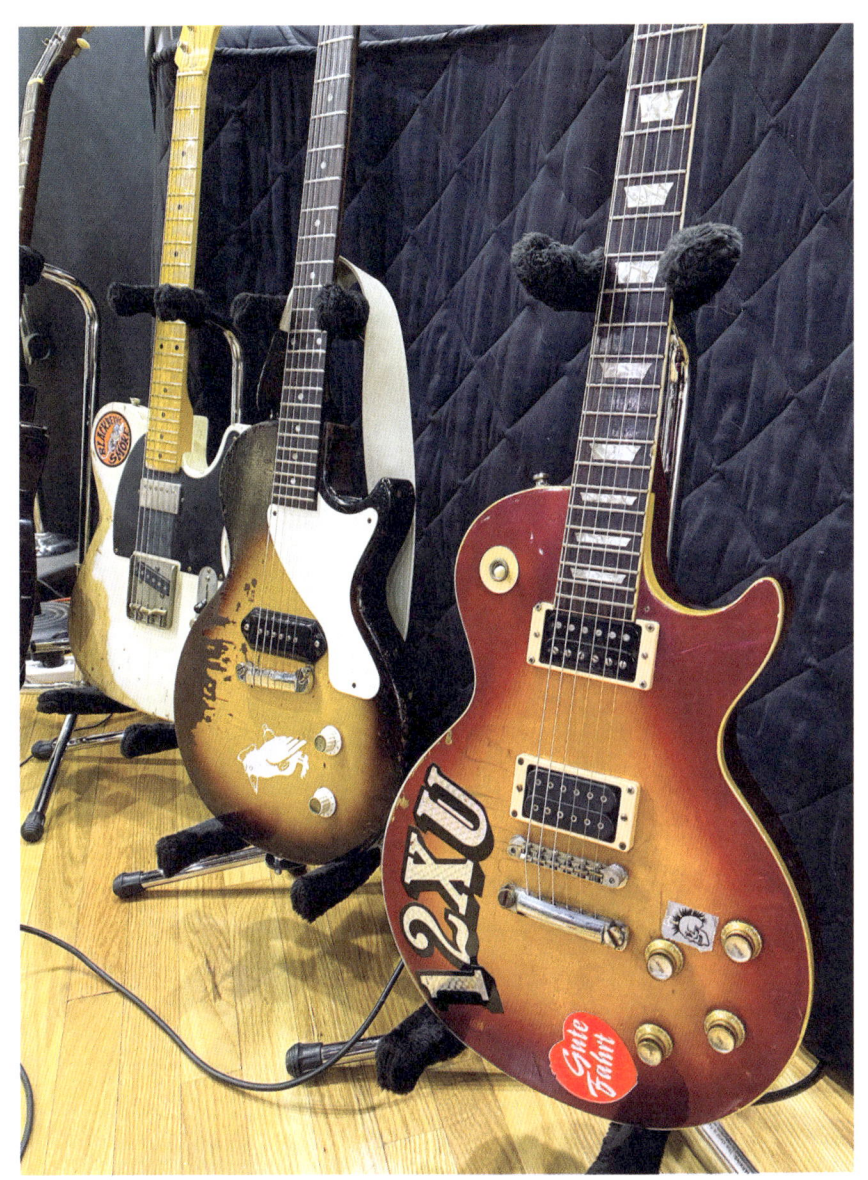

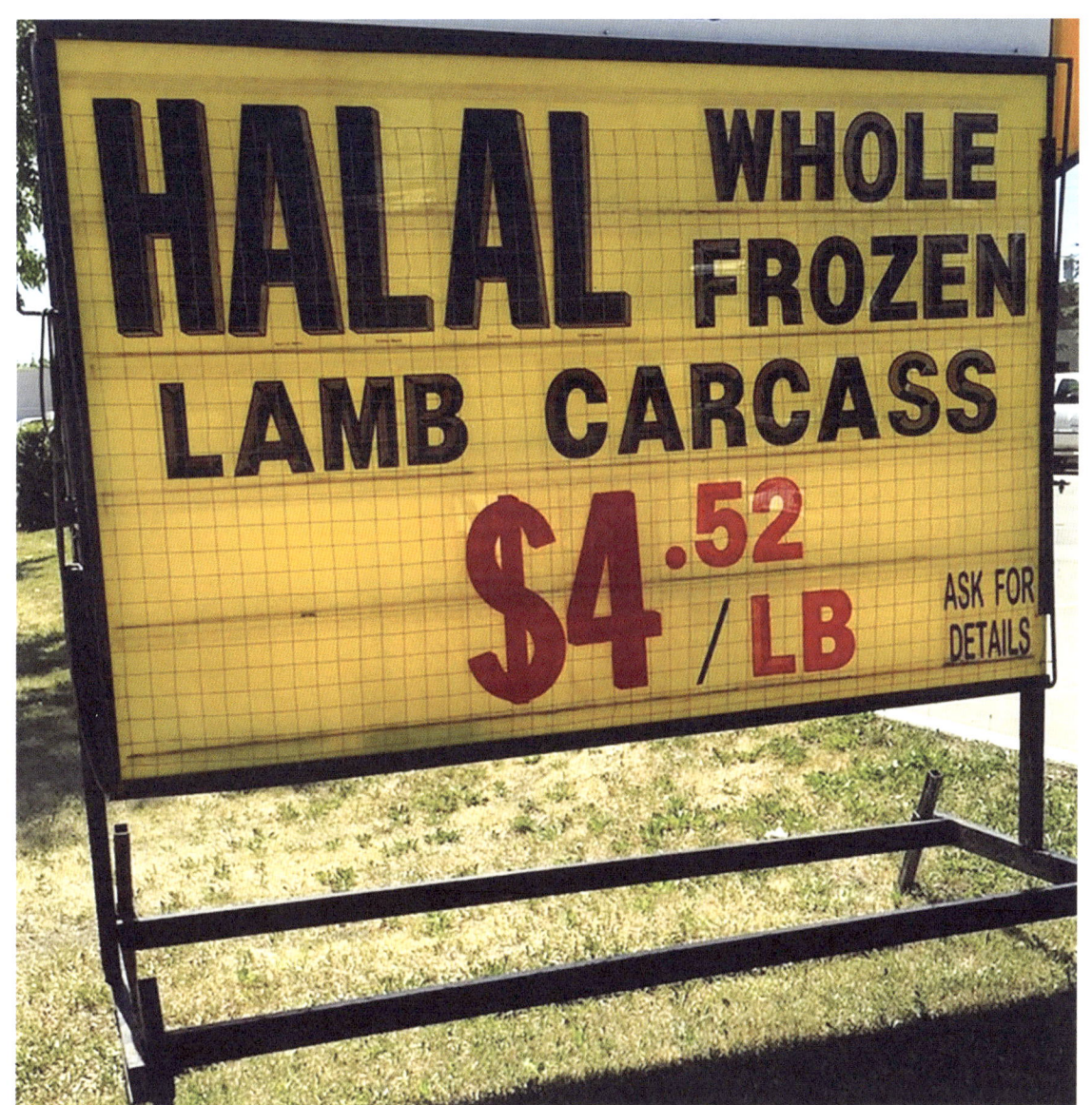

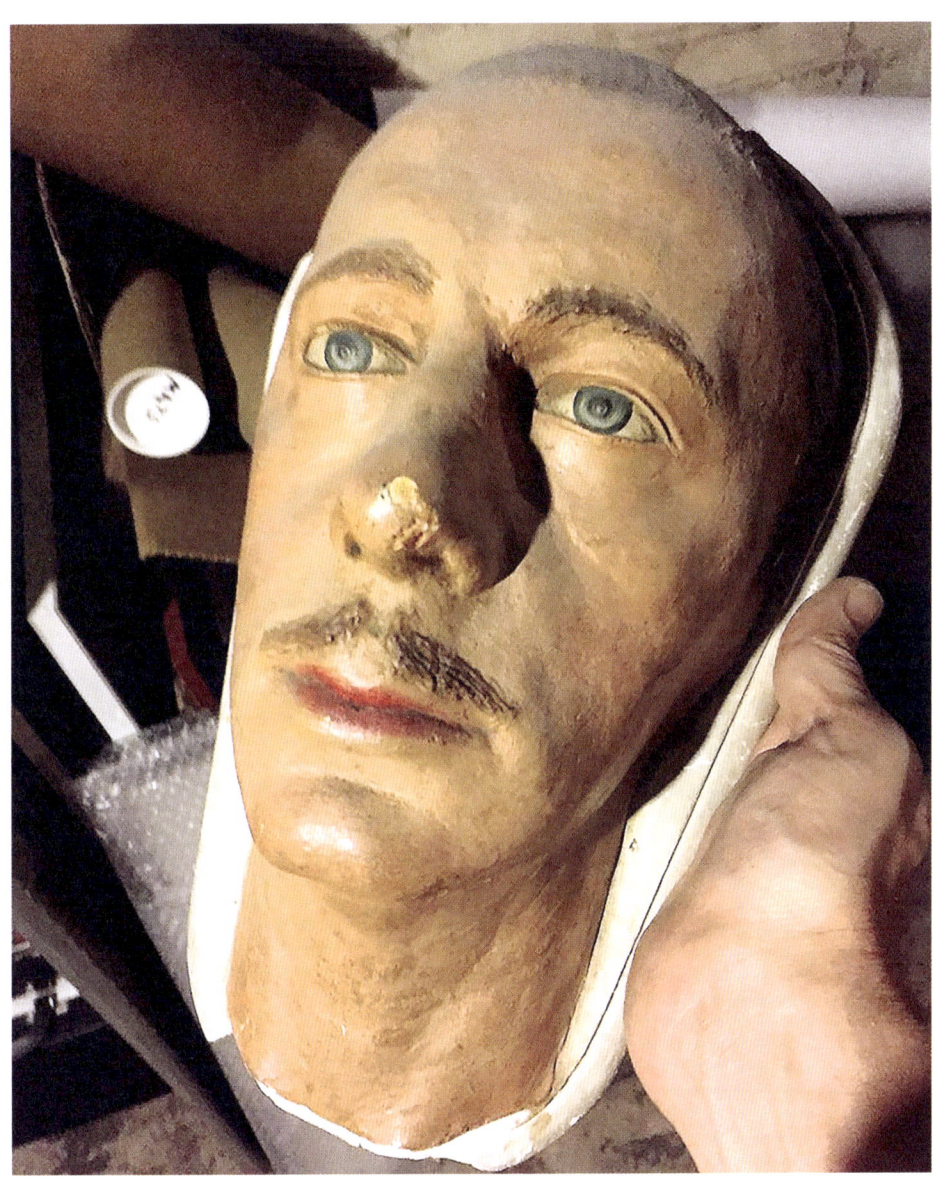

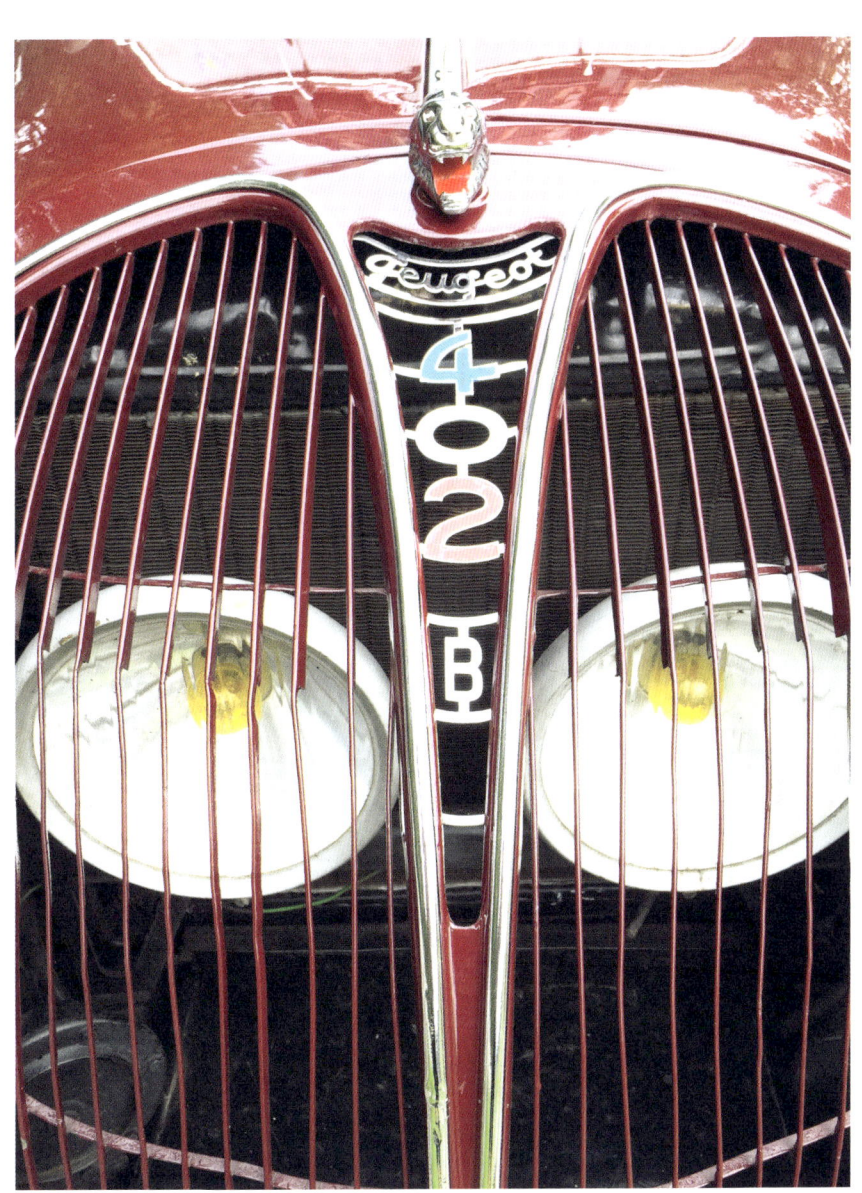

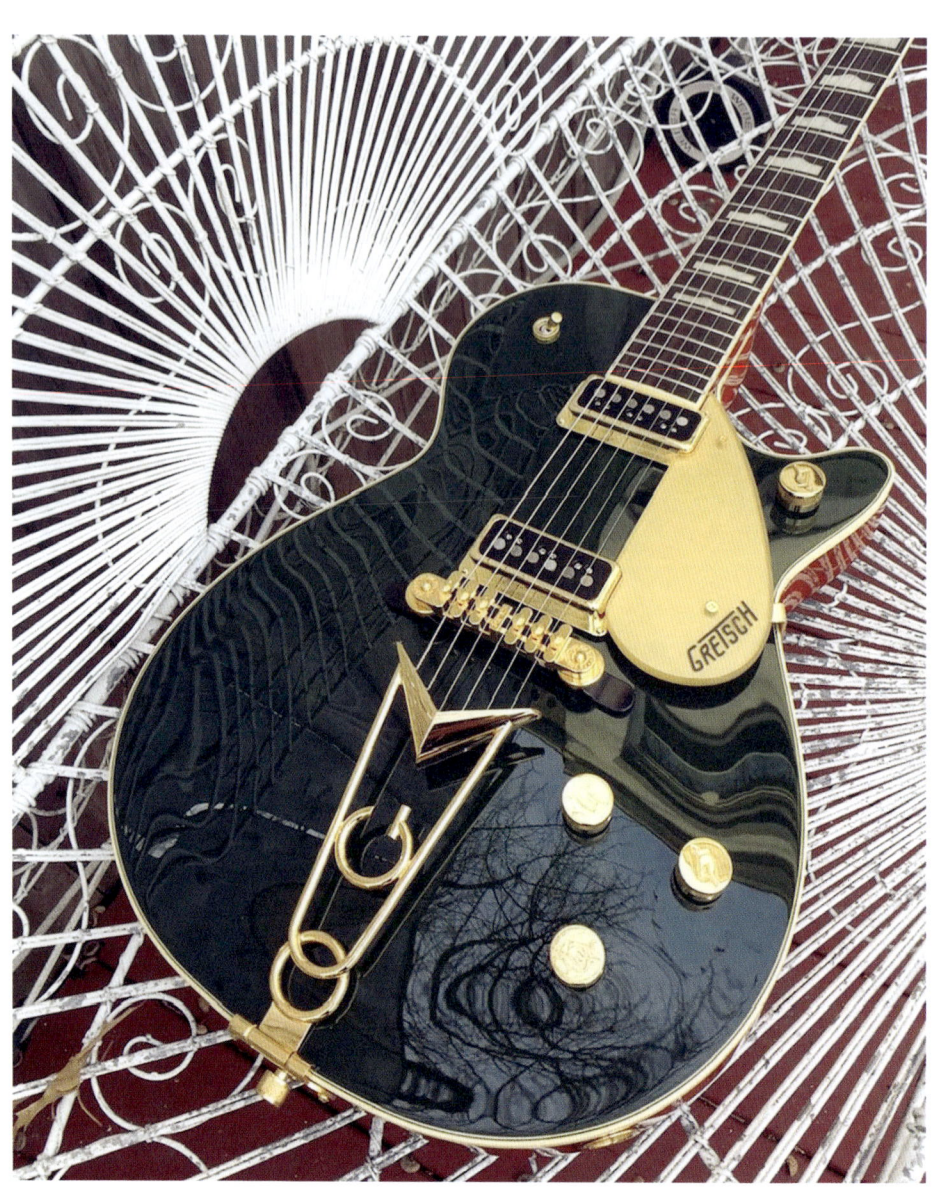

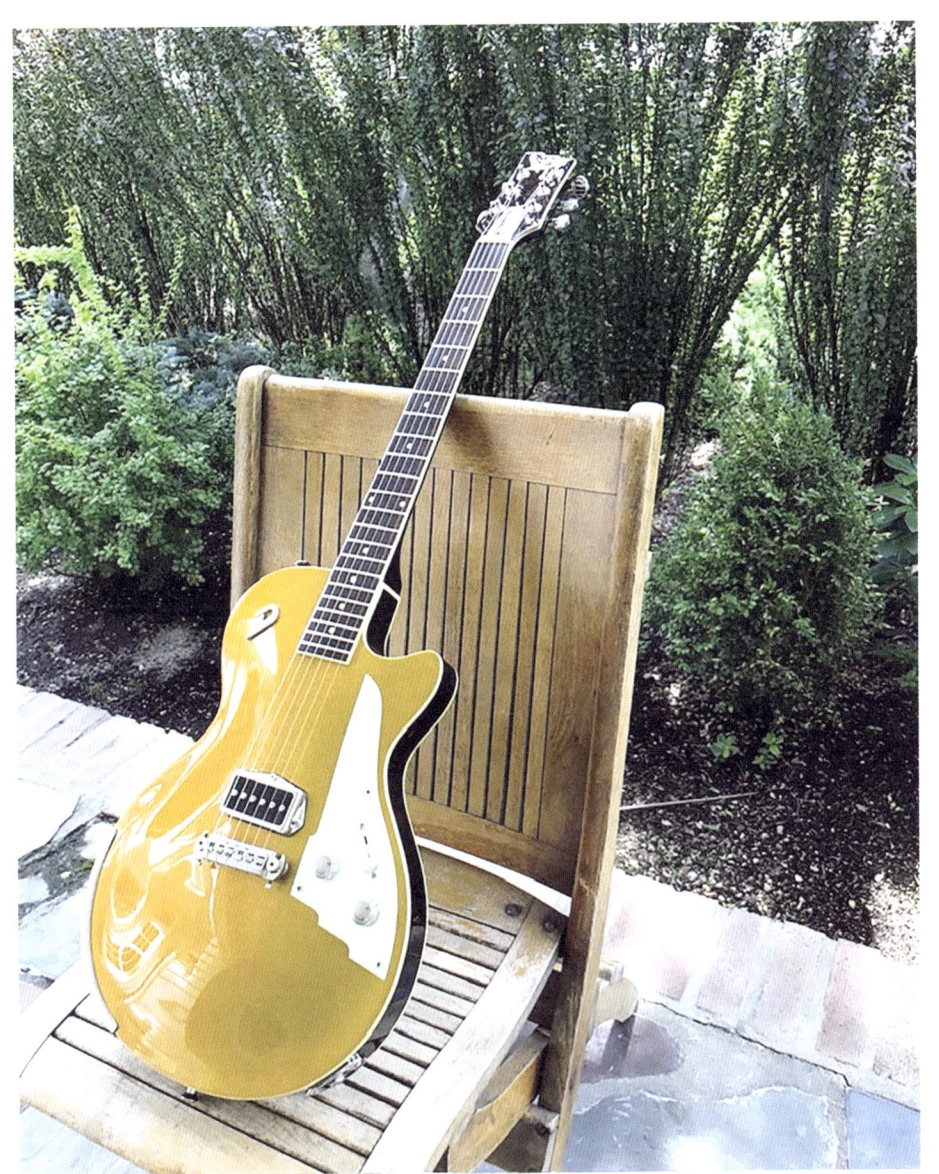

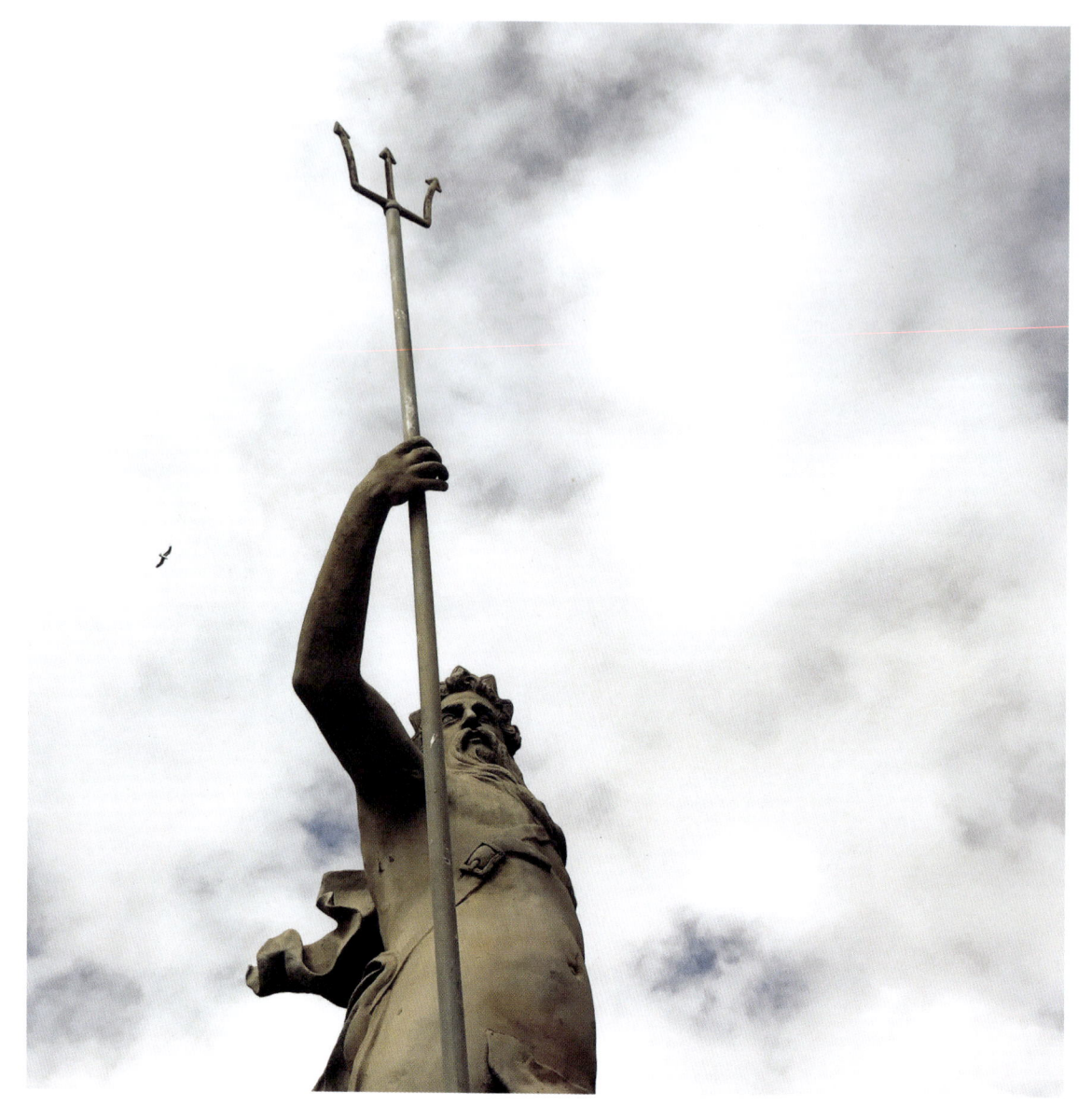

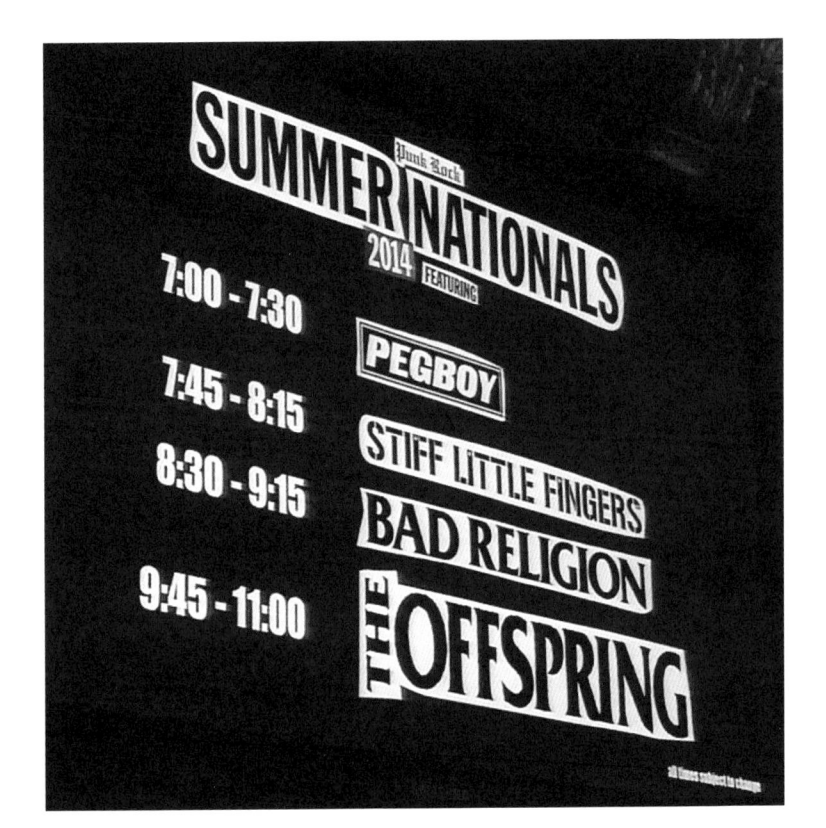

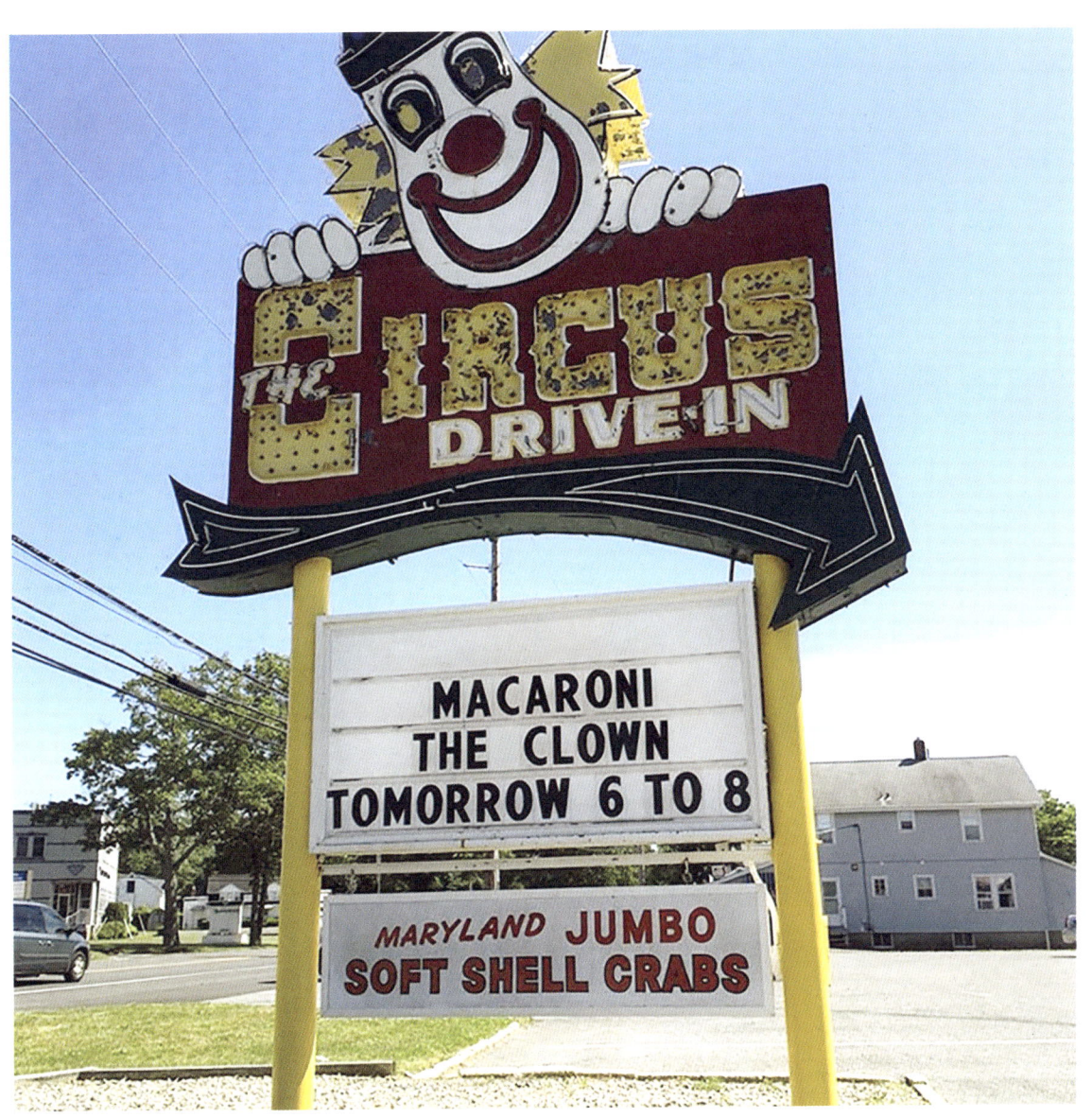

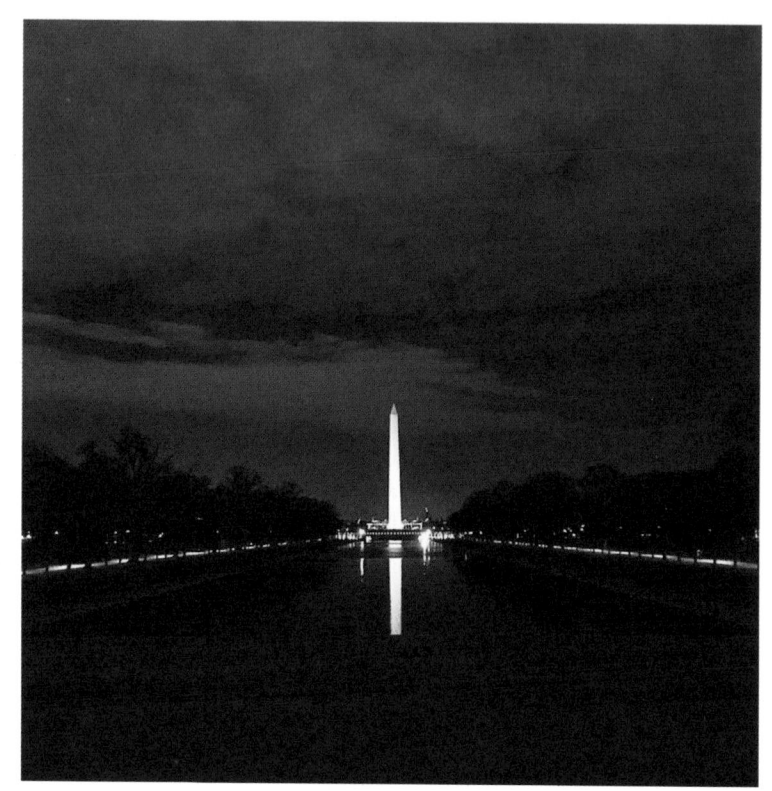

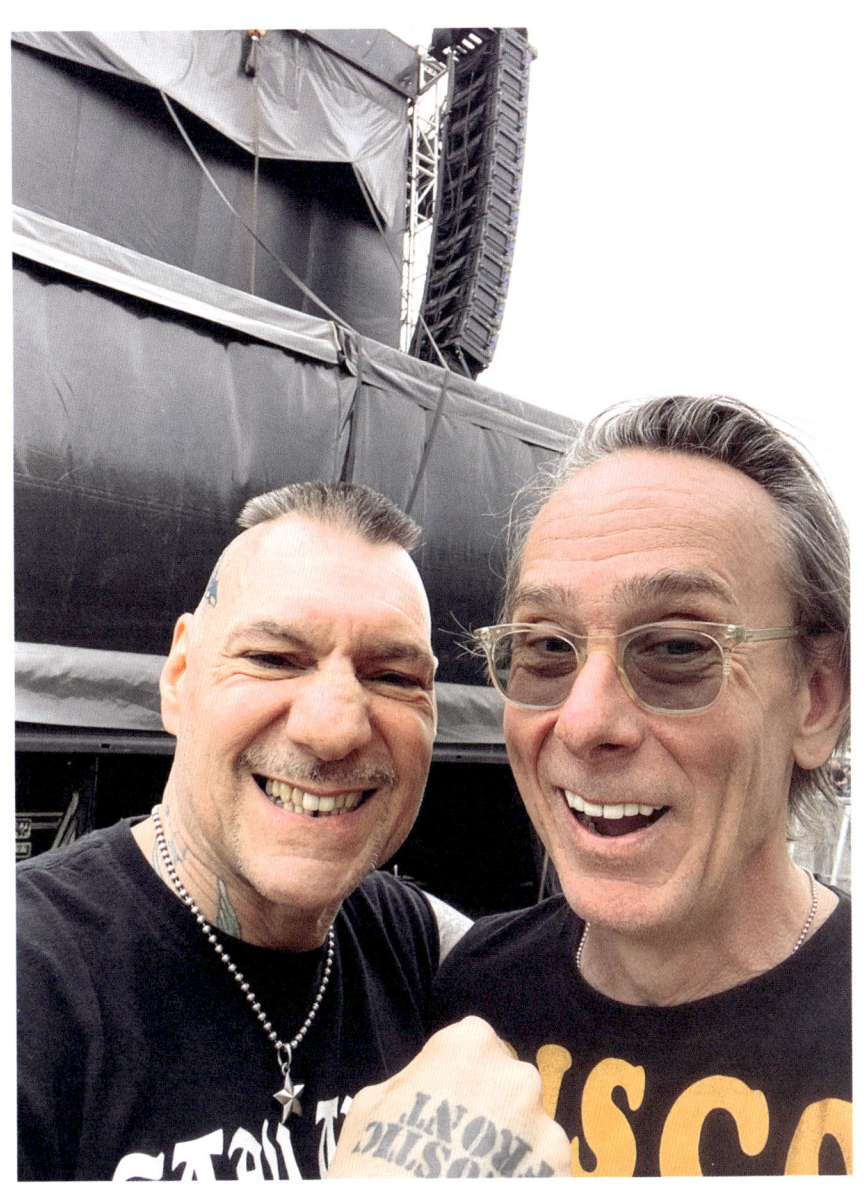

请不要喂鸽子
(会攻击喂食的人!)
No feeding, please.
(The birds will attack you!)
谢谢合作❀

138

BUSINESS
CLASS

SHOW 772

GUEST: JUDE LAW
GUEST: MIKE TYSON
GUEST: JOSH TOPOLSKY
BAND/CHEF/COMIC: BAD RELIGION
EXTRAS: JF NICK PATRICK

TWO FUN MEN

JOSH T
goggles

I drink a lot of whiskey
and smoking all the time
I'm gettin fucked up
every god damned night
everybodys doing cocaine
and starting up fights
im livin fast and hard
and dying young with my
god damned loaded fist

fury doin what i do
and im spitting in your
face cause im dominating
you

living hard n doin time
and I don't give a fuck
I been beat down n thrown
around and now you're
out of luck AND

PUNCH FIGHT FUCK

I would like to extend huge thanks to my wife, Victoria Reis, for her encouragement and insistence that this book could exist, and equally huge thanks to my great friend Jennifer Sakai who took the initiative and had the vision and talent to make it possible.

I am much obliged to Johnny Temple and all at Akashic Books for taking the risk, and as always, I am grateful to my Bad Religion family for putting me in the right places at the right times.

Stephen Jackson

BRIAN BAKER is a punk rock icon who grew up in Washington, DC. Hailed in a 2024 *Alternative Press* fan poll as one the five greatest punk guitarists of all time, he has been a pioneer of multiple styles and continues to influence and inspire new generations of listeners and players. Baker is most widely recognized for his significant contributions with legendary bands Minor Threat, Bad Religion, and Dag Nasty. He lives in Neptune, New Jersey.